My Zen

David M Rothbart

ISBN-13: 978-1533489463

Copyright ©2016 David Rothbart

www.david-rothbart.pixels.com

All rights reserved. No part of this book may be reproduced or transmitted in any form or by any means, electronic or mechanical, including photocopying and recording, or by any information storage or retrieval system except as may be expressly permitted by the author.

Dedication

This book is dedicated to those who strive to achieve personal growth by practicing love, compassion, tolerance, and exploring their personal Zen.

Introduction

The word Zen is the Japanese pronunciation of the Chinese character Chan. Zen means to find mindful awareness. People interpret their own Zen in many different ways. For some it means a peaceful existence with nature and for others it is a way to achieve inner peace.

My Zen is about learning to understand my mission in life after being dealt with a catastrophic illness, sepsis, surgery and a near death experience and to use that to develop yours. My Zen is expressed through my photography and passion for exploring reflective imagery. For me it helps to transport my creative visions beyond two dimensional viewing in my photographic art and creates my moments of Zen. Art, whether it be visual, musical, culinary or any other form of expression moves us and stimulates our emotions. The release of neurochemicals when experiencing art through viewing and listening contributes to maintaining a positive state and the mindful awareness we call Zen.

My objective, through art, is that photography will help to transport you visually and serves as a catalyst to achieve your personal Zen. May it inspire you and act as a motivator. I do not profess to be an expert in the art and practice of Zen. I only know my own personal way.

"My finger can point to the moon, but my finger is not the moon. You don't have to become my finger, nor do you have to worship my finger. You have to forget my finger, and look at where it is pointing." – Osho

About the Author

David Rothbart's love of fine arts started when he was a child. His mother was an artist specializing in oil and watercolor painting. Through her education and action, he learned to appreciate the history, depth, and creation of art. During the mid-1960's David began to experiment with photography. When he first started he, like most photographers, focused on the equipment used. As he progressed and honed his art David put less emphasis on the equipment and began to focus more on developing his eye and sense of subject selection. Over the years he learned how to use planning and visualization of the shot before he hit the shutter taking into account geometry and lighting along with subject matter. David loves architecture along with the surreal world of reflection and has made them the major emphasis of his work creating a style he calls Reflectionism.

"In any art medium I think it is important to discover the niche that grabs your soul and keeps your drive to create in constant motion".

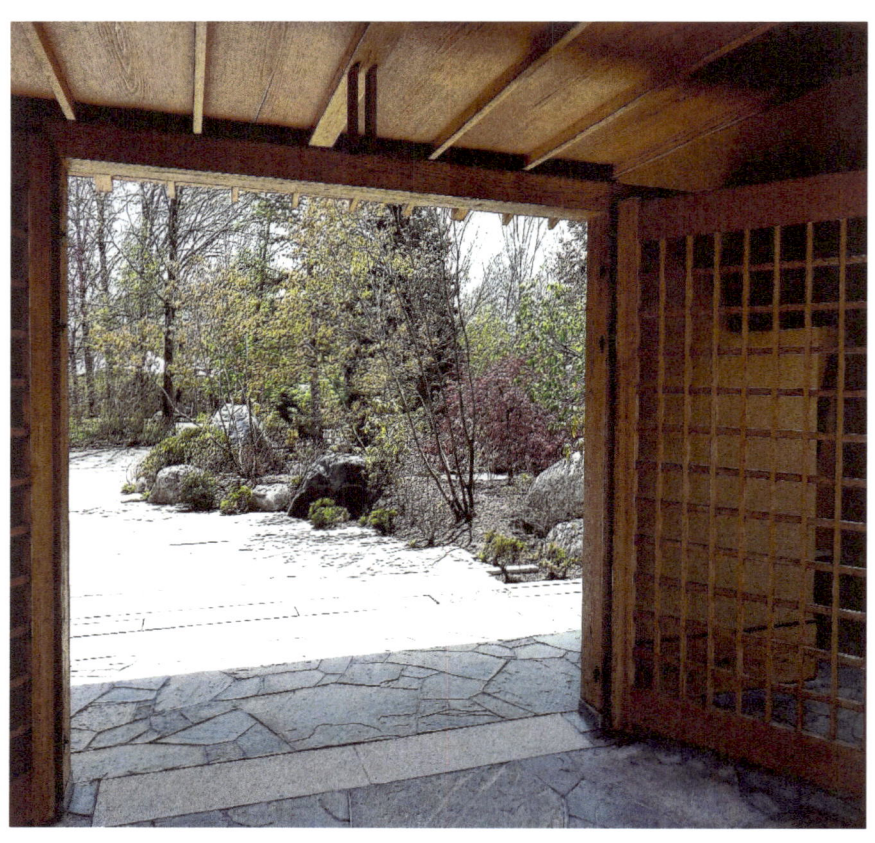

"Pathway to Zen"

Your personal pathway to Zen could be through an exotic entry to a beautiful Japanese garden like this one. I find that every time I walk into this place of tranquility I am calmed and mentally transported into a spiritual environment where I can find "my Zen".

No one saves us but ourselves. No one can and no one may.
We ourselves must walk the path. – Buddah

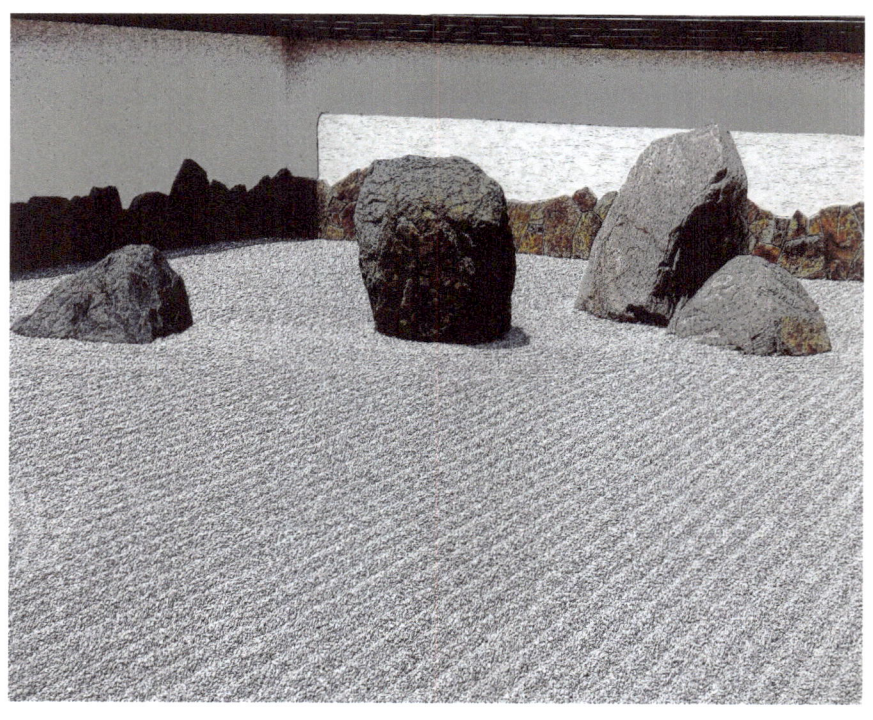

"Zen Garden"

This Zen garden is a refuge, a quiet space where you can sit in a place of peace and reflect on your inner most secrets or nothing at all. Your eyes are fixed on the patterns in the gravel and your ears absorbing the sounds of silence. A barrier wall separates you from elements on the outside of this spiritual cocoon.

When a garden is used as a place to pause for thought, that is when a Zen garden comes to life. When you contemplate a garden like this it will form as lasting impression on your heart. - Anthony Lawlor

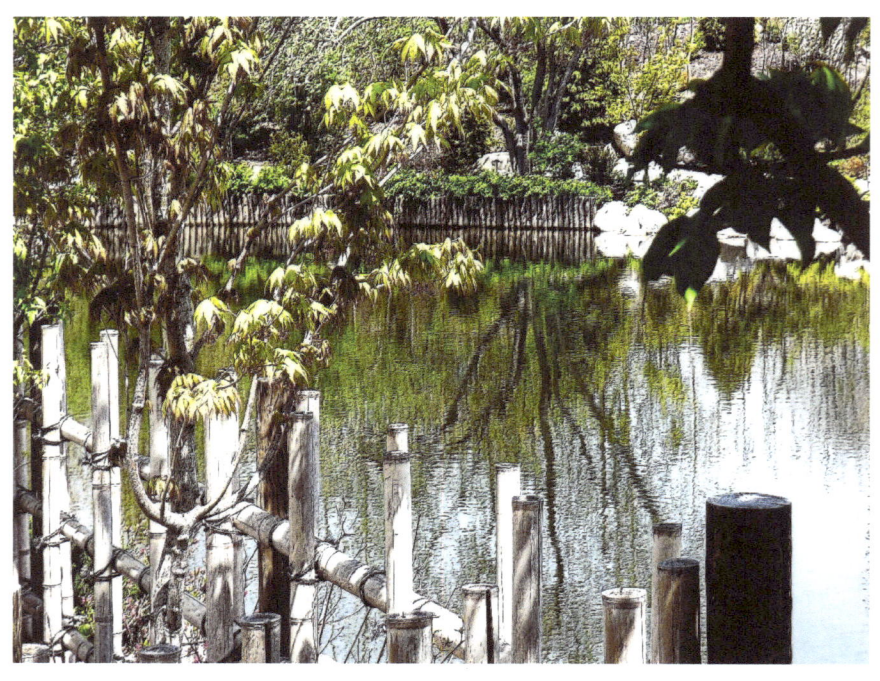

"Bamboo Fence"

The significance of bamboo in Japanese culture is its representation of prosperity. The plant signifies strength due to its rugged root structure. When you observe the bamboo fence on the pond you are reminded of your own inner strength coupled with the feeling of floating on water. The warm breeze and serenity of the moment help to calm your mind and help you to move away from unnecessary thought.

Bamboo is flexible, bending with the wind but never breaking, capable of adapting to any circumstance. It suggests resilience, meaning that we have the ability to bounce back even from the most difficult times. . . . Your ability to thrive depends, in the end, on your attitude to your life circumstances. Take everything in stride with grace, putting forth energy when it is needed, yet always staying calm inwardly. - Ping Fu

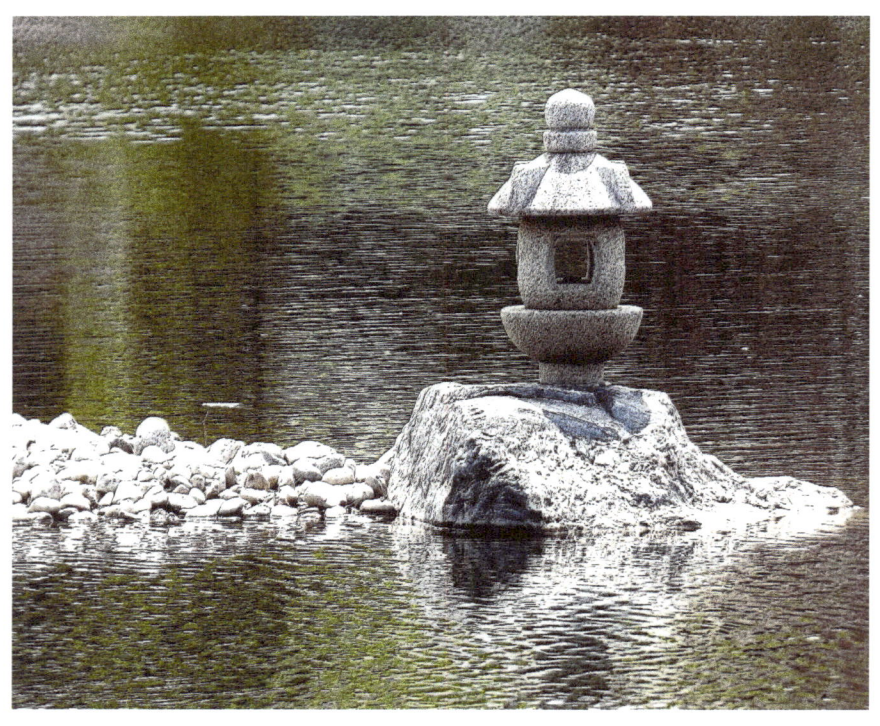

"Pebble Beach"

The elements of a Zen garden are water, rock, wood and plants strategically placed as a spiritual landscape. There is no need to focus on the scenery, just let it become part of you and your personal Zen experience. Clearing your mind takes practice and having an inviting setting helps the process along. After a while the tranquility just seems to overtake your being – let the flow of nature become part of you.

Empty your mind, be formless, shapeless - like water. Now you put water into a cup, it becomes the cup, you put water into a bottle, it becomes the bottle, you put it in a teapot, it becomes the teapot. Now water can flow or it can crash.
Be water, my friend. – Bruce Lee

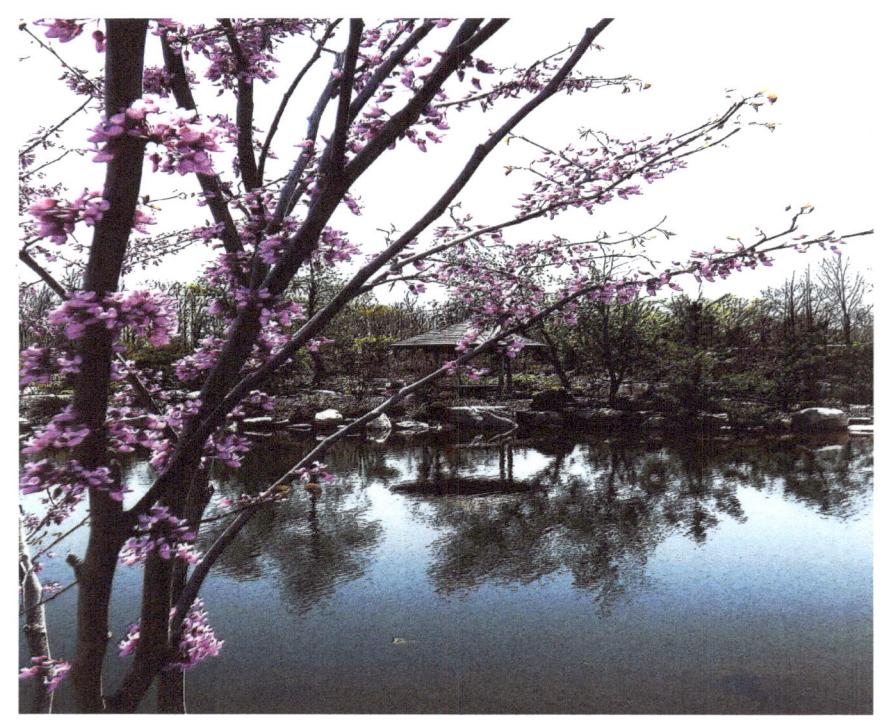

"Pink Blossoms"

As the new born pink blossoms of spring awaken we are reminded that the awakening of our mind empowers us with renewal. In Japanese culture the blossoms symbolize hope, mortality and humanity. The life of the blossom is short and it causes us to realize because we are mortal and life can end in an instant we need to cherish every moment and seek pleasure to nourish our mind and spirit.

Blossom smile some sunshine down my way lately I've been lonesome. Blossom it's been much too long a day, seems my dreams have frozen, melt my cares away. – James Taylor

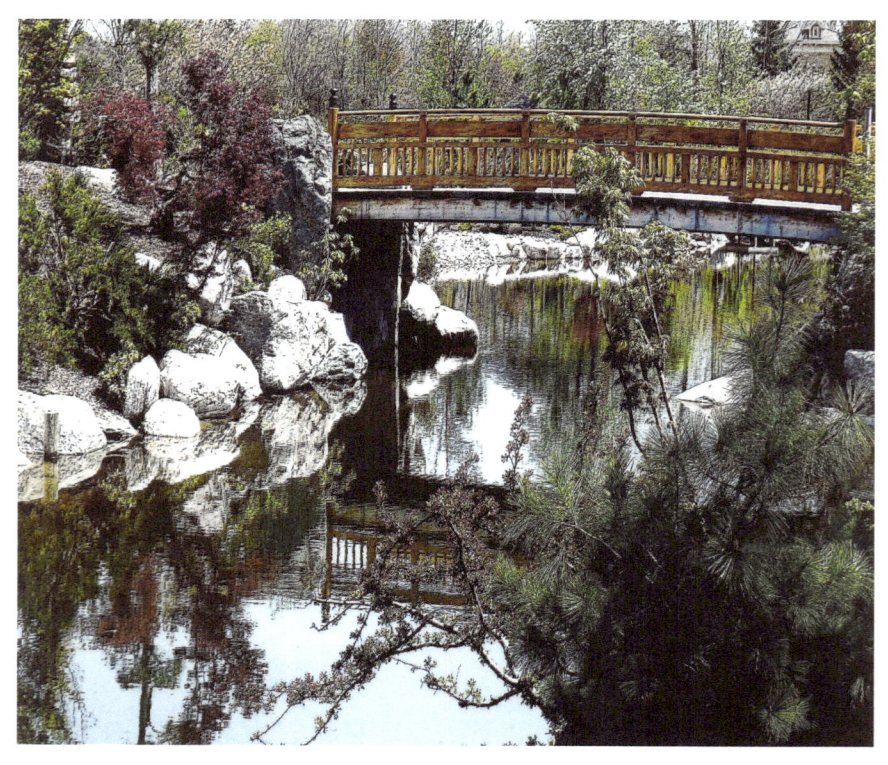

"Bridge Pond Reflection"

Bridges signify transition. When we enter the threshold of a bridge, from either end, we are making a transition that brings us closer to achieving our Zen. As we move across the bridge we are visually drawn to the reflections in the water which helps contribute to our spiritual journey. The bridge, even though fixed, represents movement, crossing from one spiritual plane to another. As you cross the bridge, study each part of the structure by completely opening your peripheral vision to see and absorb its intricacies. The rigidity of the bridge helps to keep you focused in the moment.

When we continually burn our bridges there will be none left the next time we need to cross one. – David Rothbart

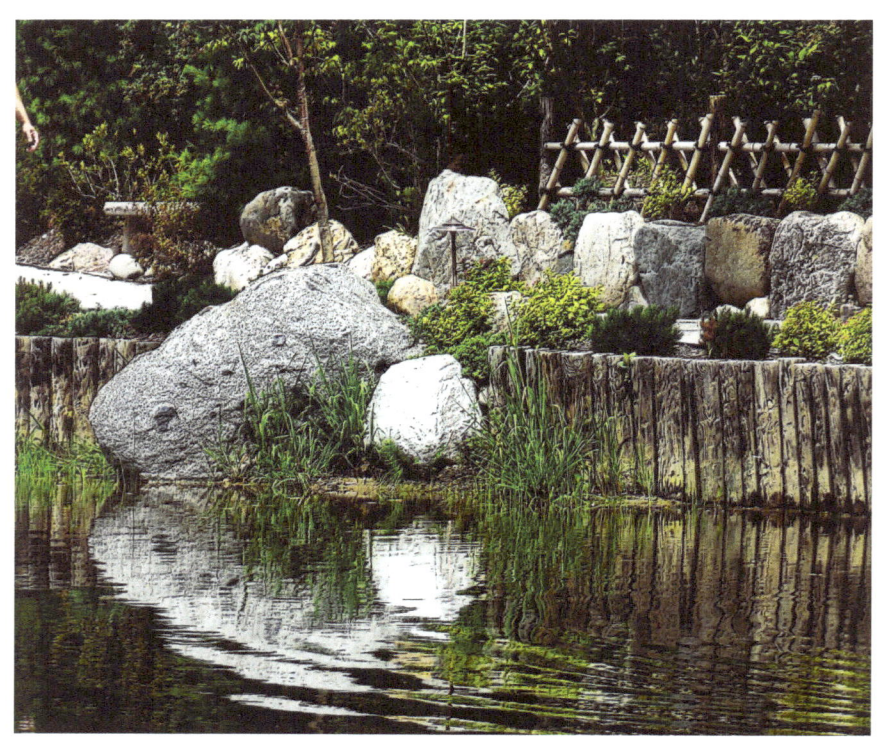

"Ripple of Dreams"

The ripple of our dreams and thoughts spark images that if harnessed propel us toward our center and Zen. When you toss a pebble into a pond the water ripples outward from the center in all directions. In life our focus should be on capturing those ripples and riding on their crest as they exemplify our thoughts and emotions. The rocks in a Zen garden sometimes symbolize mountains. If a mountain is weak it does not have stones for support and by the same token If we are weak it is because we do not have proper support. When we construct our own emotional and spiritual mountains it is important to make sure we have sufficient rocks in place for support.

The only thing that is ultimately real about your journey is the step that you are taking at this moment. That's all there ever is. - Eckhart Tolle

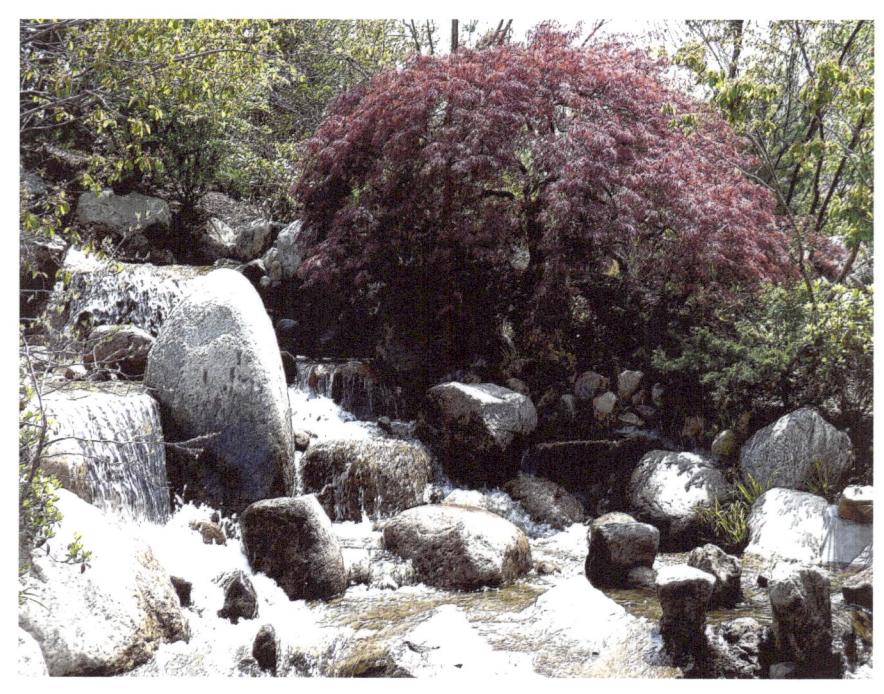

"Japanese Red Maple"

The Japanese Red Maple has been one of the cornerstones of Zen gardens. The maple tree represents harmony. In our busy daily lives we often overlook creating harmony within our being. All of us are part of nature and we should strive to stay in touch with it in our daily lives to achieve our personal Zen. The best way to do this is to enjoy a setting where our role is not that of conqueror or observer, but rather participant. In life, if the chorus only sings the same note there is no harmony.

When we feel, a kind of lyric is sung in our heart. When we think, a kind of music is played in our mind. In harmony, both create a beautiful symphony of life.
- *Toba Beta*

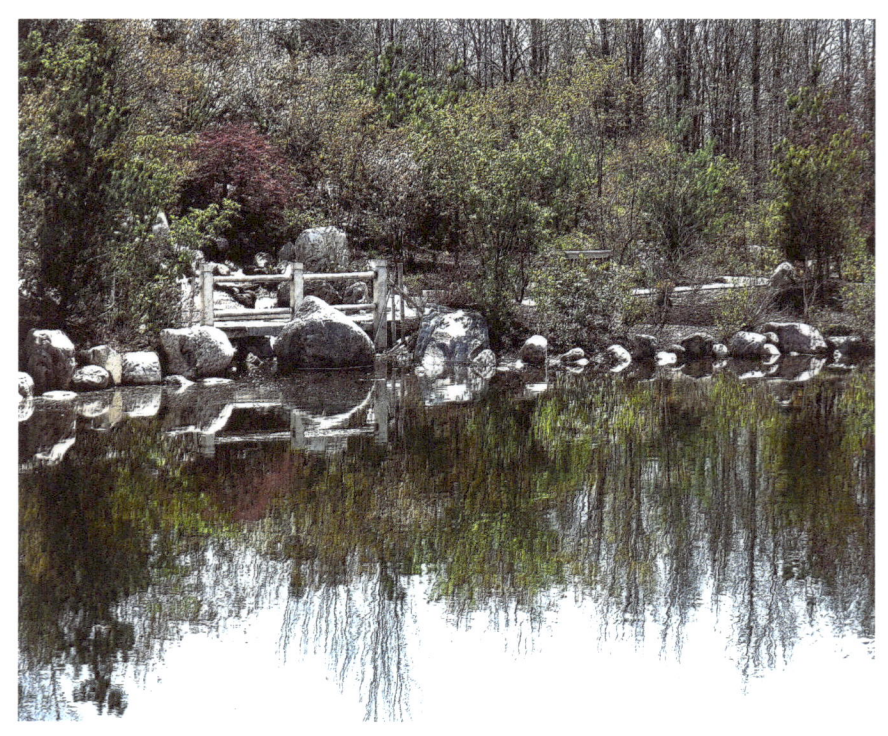

"Pond Reflection"

Pond reflections in a Japanese garden signify mirrors of our thoughts, dreams and meditations. Reflections help draw us toward achieving our personal Zen acting as a catalyst to guide us toward relaxation of our mind. These reflections can create a powerful visual experience that moves us inward. I enjoy sitting at a reflection pond and letting the moment take over my being as I become one with the landscape before me.

And that was, is. Life sometimes flips on you like that. One minute you're looking at your reflection in the water, not entirely sure you like what you see, and the next minute you are upside down, submerged in a world where even familiar things look new. - Vicki Pettersson

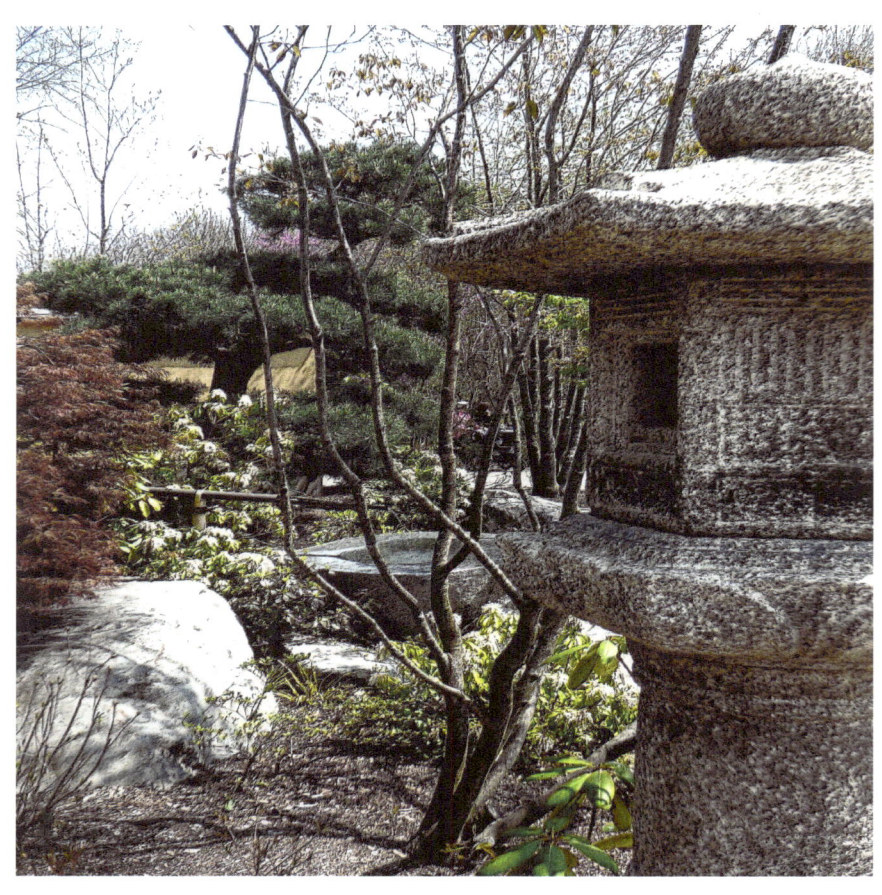

Stone Pagoda

Lanterns and pagodas were once lit as an offering to Buddha. Now they are used as ornamental objects. I like to think of these lanterns and pagodas as a place to hold your thoughts and dreams like a vault. When we meditate in a garden it is nice to have a place to put your thoughts so they can cultivate until you return. This can act as a means to spark your positive memories the next time you visit and your prior experiences can be resurfaced to use or edit with your mind's eye.

We walked at night towards a cafe blooming with Japanese lanterns and I followed your white shoes gleaming like radium in the damp darkness. Rising off the water, lights flickered an invitation far enough away to be interpreted as we liked; to shimmer glamorously behind the silhouette of retrospective good times when we still believed in summer hotels and the philosophies of popular songs.
 - Zelda Fitzgerald

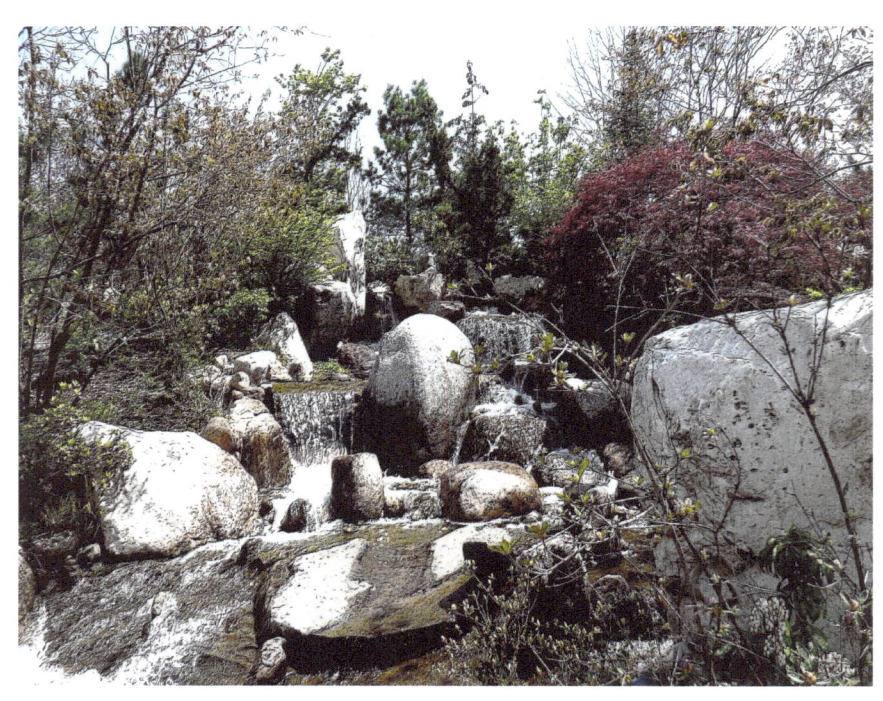

Serene Waterfall

Waterfalls delight our visual and hearing senses. The flow of water and the sound associated transport us toward our Zen. Water is a primary element in Zen gardens and is one of the five elements in Japanese philosophy. Water at Buddhist shrines symbolizes the aspiration to cultivate the virtues of calmness, clarity and purity with our body, speech and mind.

Water is life's mater and matrix, mother and medium. There is no life without water. - Albert Szent-Gyorgyi

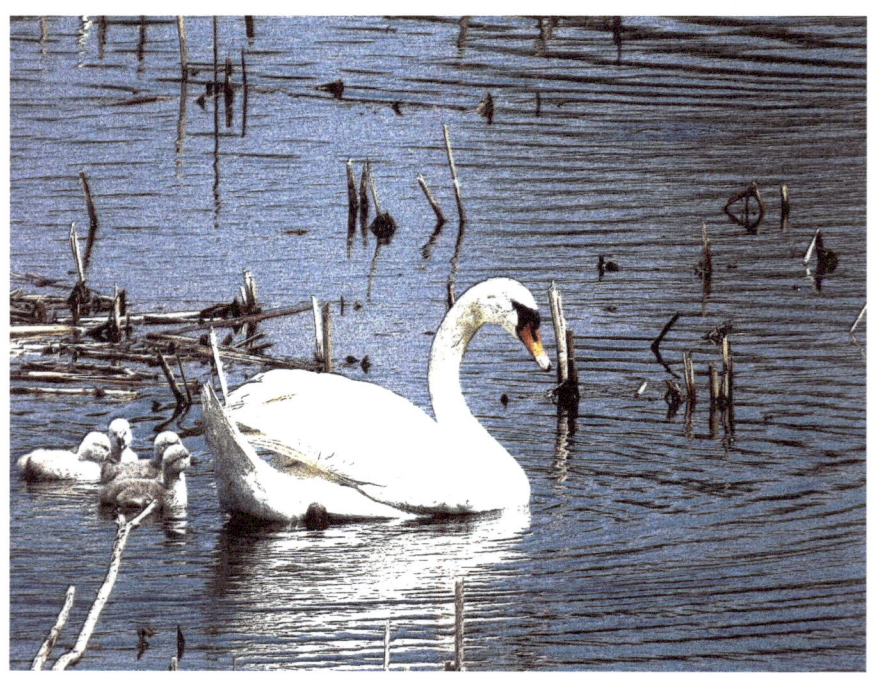

Swan and Chicks

Swans represents grace, beauty and are associated with love, poetry and music. Balance in life both spiritually and physically are the corner stones of achieving Zen. I have marveled at the how people are draw to the beauty and gracefulness of this animal and how their presence in a Zen garden helps one to achieve their own sense of grace and beauty.

Being born in a duck yard does not matter, if only you are hatched from a swan's egg. - Hans Christian Andersen

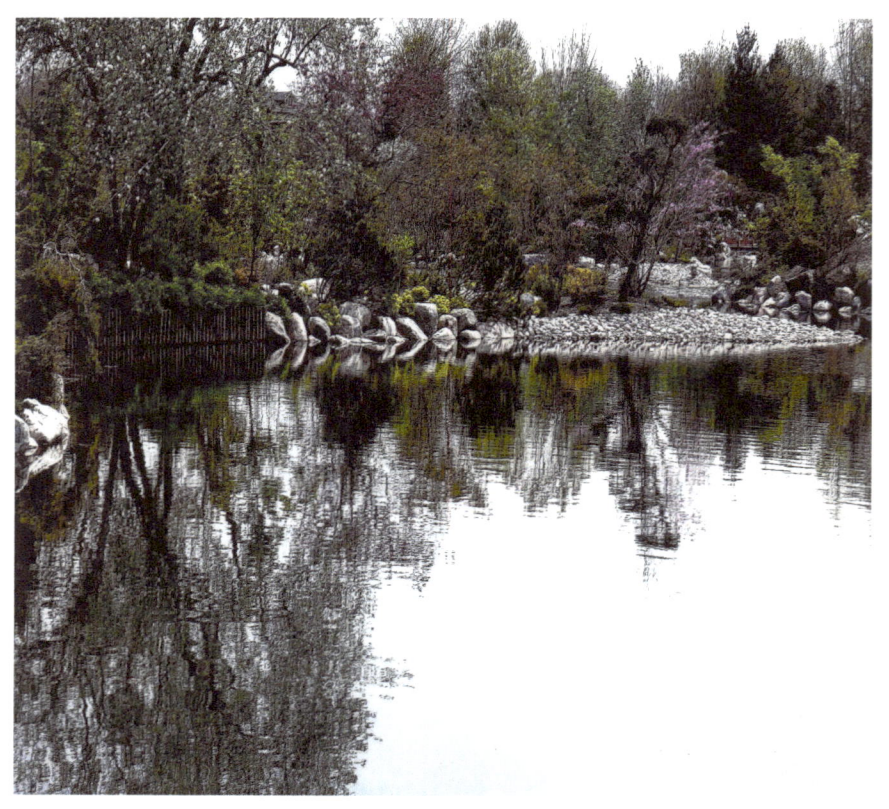

Lagoon

A Zen garden is complete when the essential elements are present and through synergy awaken the five senses. In addition to water, stone, trees, plants and wooden structures people are also an essential element. When you have young and old together the children are an expression of how as the garden grows they will grow from the wisdom of their elders. This gift of human energy stays in the garden and is there to be drawn on to enhance your personal Zen.

Blessed are they who see beautiful things in humble places where other people see nothing. — Camile Pissarro

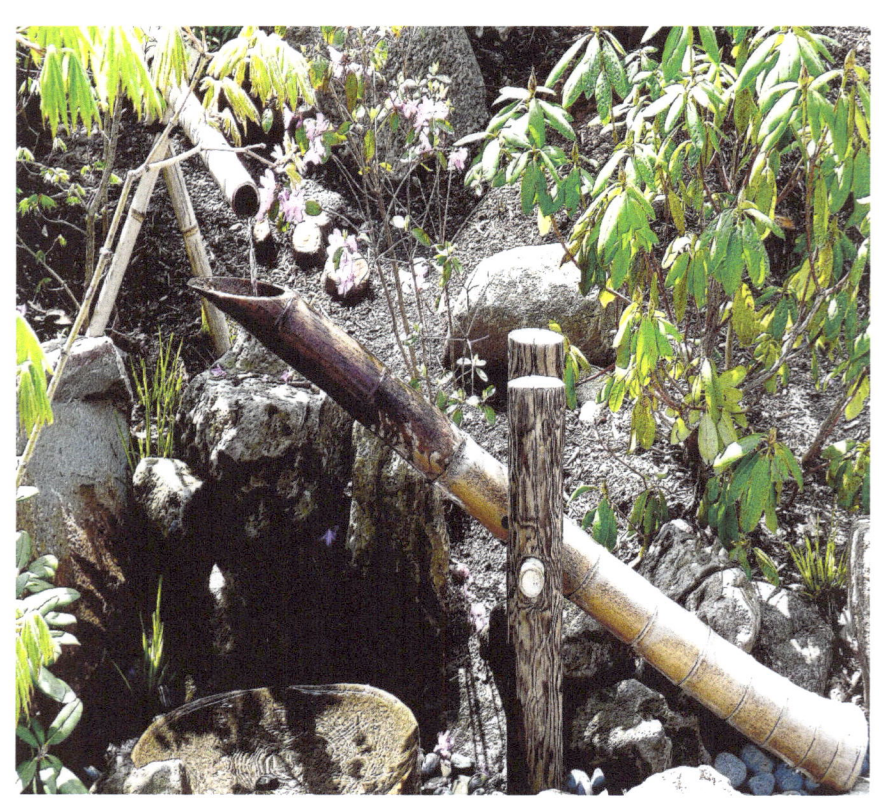

Japanese Water Fountain

The bamboo water fountain creates a unity between the outdoors and the indoors by completing the harmony of nature and structure. In our own lives we strive to have that harmony between our world and our bodies. When we harness the two as one we realize Zen. Harmony is when the elements of nature and self-become one without effort. If everyone on the choir sings the same note, there is no harmony.

The demonstration of cognitive abilities from a wisdom perspective benefits not only the individual in terms of solving life problems, but also benefits interpersonal relationships, as well as society as a whole. - Linda C. Osterlund

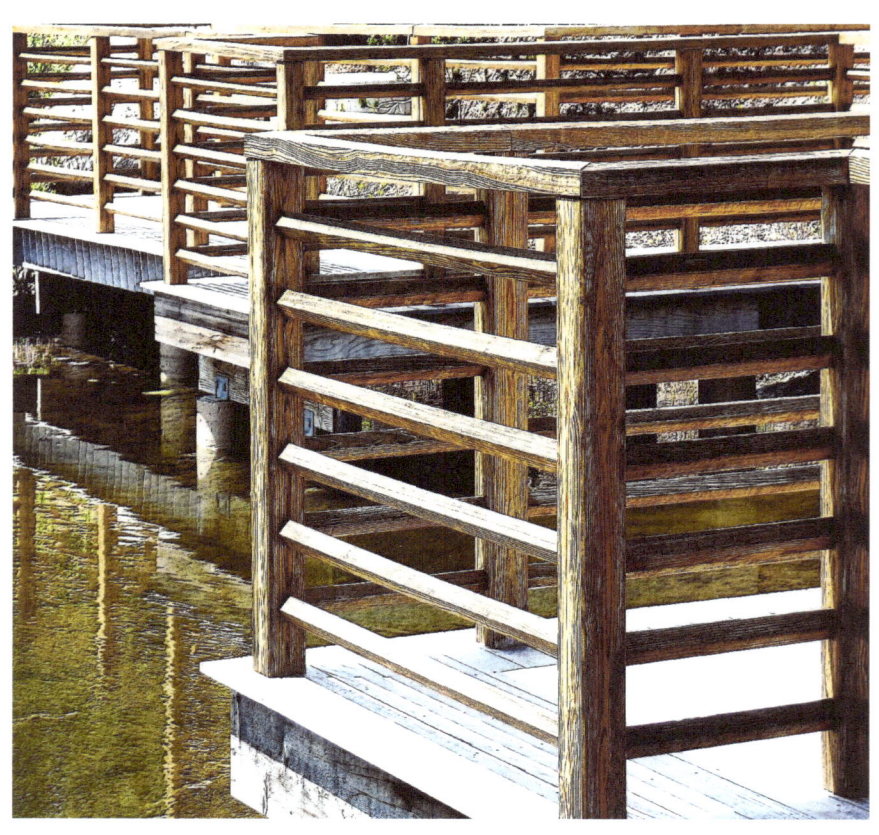

View Through the Fence

Adjusting symmetry in our lives can have great impact in our lives. When we create focus to our personal symmetry it can have a profound effect finding a healthy balance and enhance our personal Zen. Fences in a Zen garden represent that symmetry and help to see more clearly. They have an effect of generating a sense of centering to our thoughts.

Symmetry, as wide or narrow as you may define its meaning, is one idea by which man through the ages has tried to comprehend and create order, beauty, and perfection. - Hermann Weyl

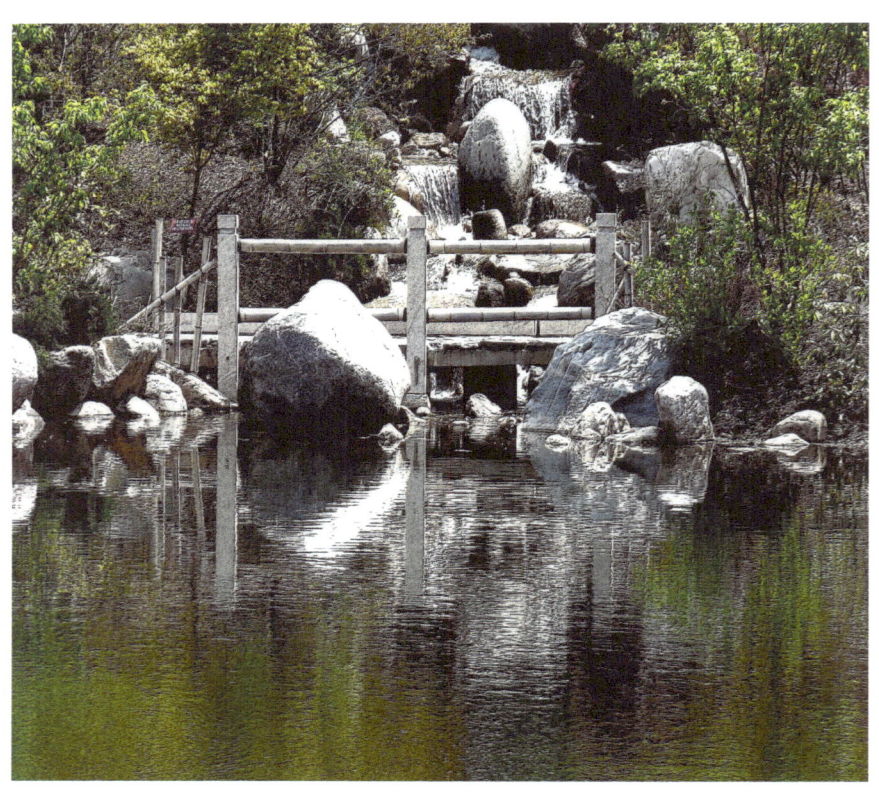

Waterfall and Bridge

The elements of water, bridges and stones in a Zen garden represent the study of nature in Buddhism. They capture the philosophy of making a peaceful way. As you walk across the bridge and hear the flow of water cascading slowly past the rocks there is a oneness with nature that flows through your being. As you begin to find your peaceful way with nature you will also find your Zen.

There is a waterfall in every dream. Cool and crystal clear, it falls gently on the sleeper, cleansing the mind and soothing the soul. - Virginia Alison

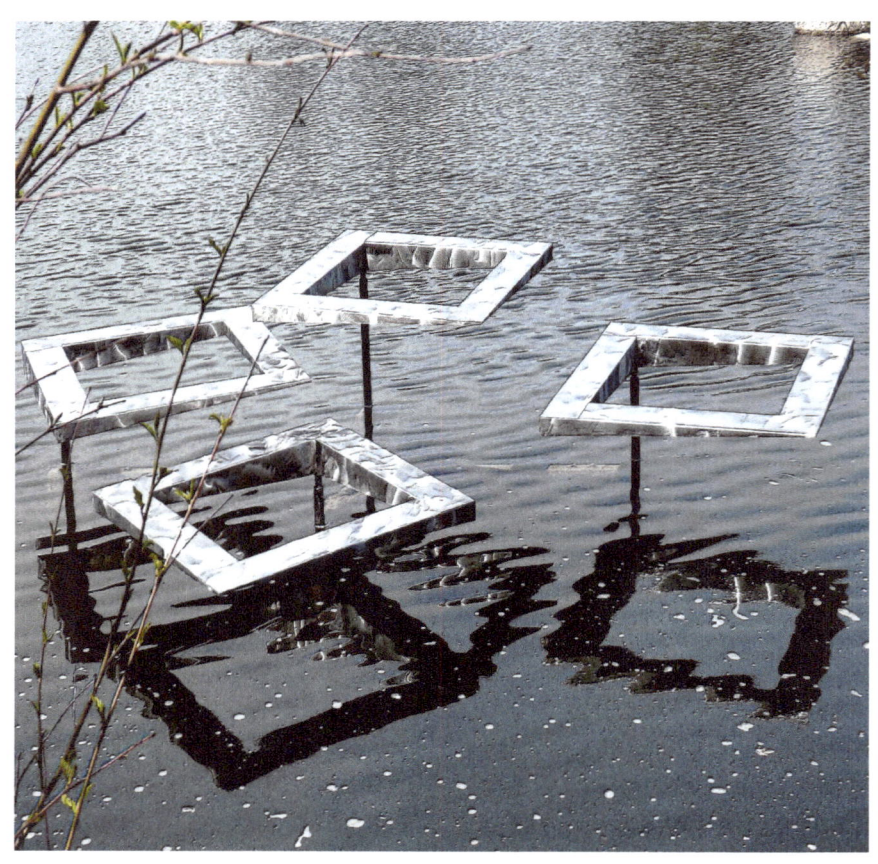
Water Sculpture

The water sculpture is elegant in its visual simplicity. It speaks towards extending one's mind by using the squares as a metaphor for both tranquility and perception of change. Each sculpture depicted has a beginning but no defined end. This is like life's energy in the universe having a starting point by mark alone and an endless connection to its beginning.

There is no end. There is no beginning. There is only the passion of life.
- *Federico Fellini*

www.ingramcontent.com/pod-product-compliance
Lightning Source LLC
Chambersburg PA
CBHW041145180526
45159CB00002BB/732